ABOUT THE ILLUSTRATOR

ERIN JONS is a self-taught artist who enjoys the intricacies of creativity. Her relationship with paper and ink began in 1998 as she drew, sketched, and doodled her way through the trials of high school lectures. This relationship has continued in the form of portraits, theatrical set design, and drawing countless coloring pages for her own children. She is humbled and delighted to see her art mingle with God's precious and powerful Word, and prays that time spent with each page will reveal a glimpse of the beauty of Jesus. Erin is happily married with five children in Northern Idaho.

INTRODUCTION

WHY ADULT COLORING BOOKS?

There is plenty of research that shows coloring to be an effective stress reducer. Maybe you picked up this book because you've heard the hype and you're curious. Perhaps you've been searching for a way to relax. Or, if you're like many others we've encountered, you've been looking for a good excuse to color since you grew up and coloring books were no longer an acceptable hobby. Over the years, you may have found yourself eager to babysit kids who were fond of coloring, or maybe you have children or grandchildren of your own that "need" your help filling in the pages of their coloring books.

Finally, you hold in your hands your very own adult coloring book. And you have every reason you need to sit down and color. You have entered a stress-free zone. There's no wrong way to do this. If you want the grass to be blue and the sky to be green, go right ahead. If you only want to color a portion of a picture, do it. Crayons? Coloring pencils? Markers? It's your choice. This is your book, and this is your time.

Let's take it a step further. While coloring may be a great distraction from all you have going on, the best way to find lasting peace is to spend time with your Creator. As you fill these intricately designed illustrations with the beauty of color, dwell on the richness of his Word, the faithfulness of his character, and the depth of his love for you.

> "I HAVE TOLD YOU THESE THINGS, SO THAT IN ME YOU MAY HAVE PEACE.
> IN THIS WORLD YOU WILL HAVE TROUBLE.
> BUT TAKE HEART! I HAVE OVERCOME THE WORLD."
> JOHN 16:33 NIV

Happy coloring!

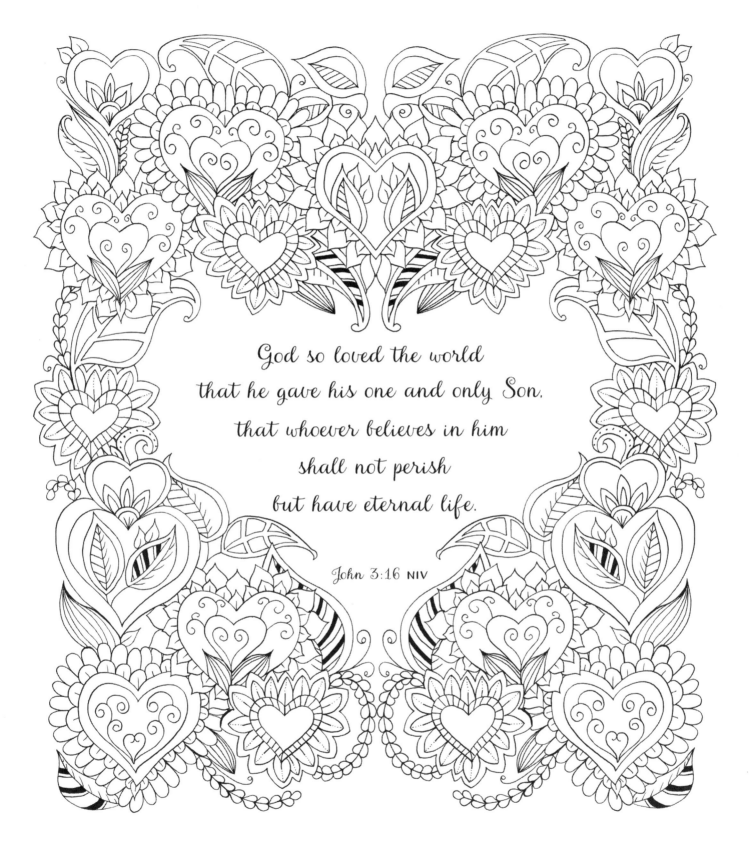

God so loved the world
that he gave his one and only Son,
that whoever believes in him
shall not perish
but have eternal life.

John 3:16 NIV

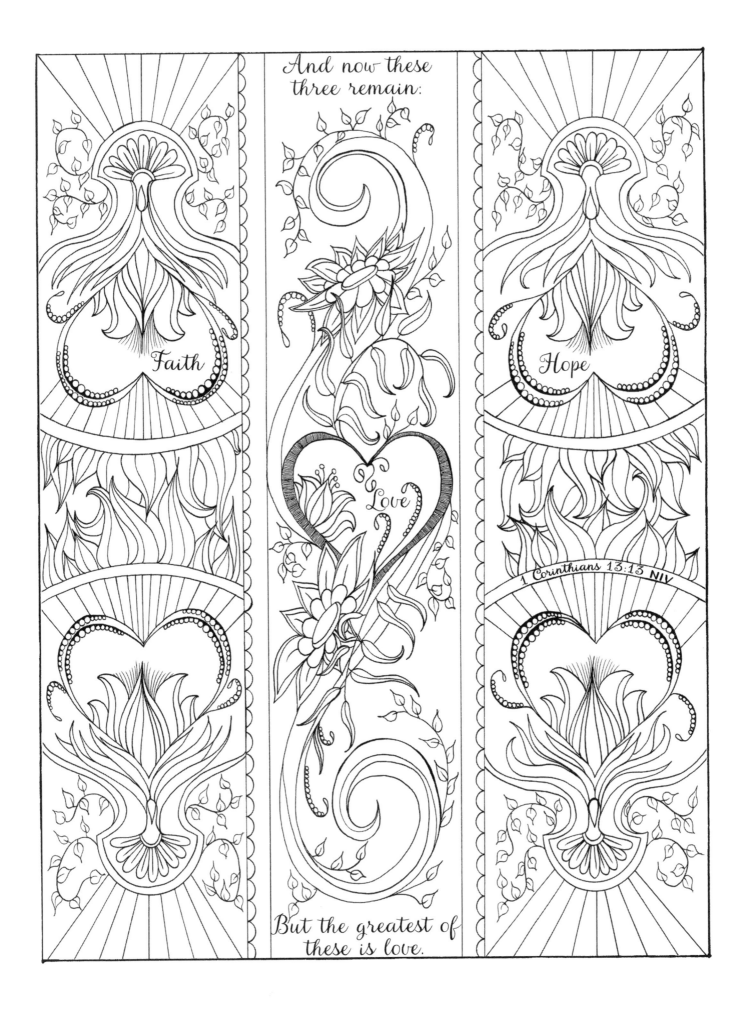

And now these three remain:

Faith

Hope

Love

1 Corinthians 13:13 NIV

But the greatest of these is love.

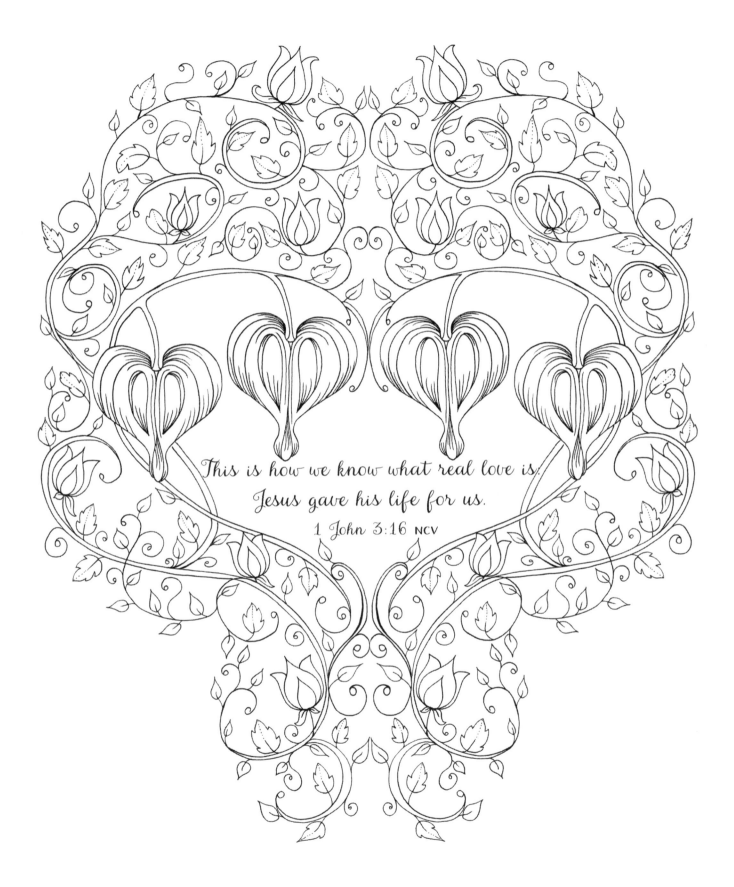

This is how we know what real love is:
Jesus gave his life for us.
1 John 3:16 NCV

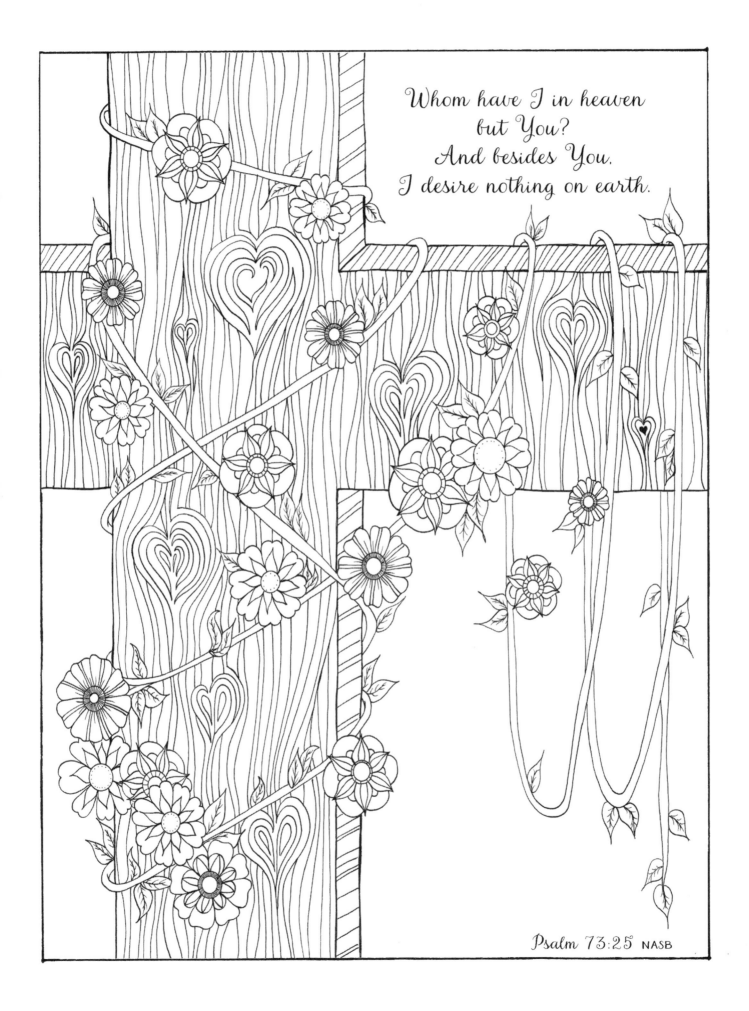

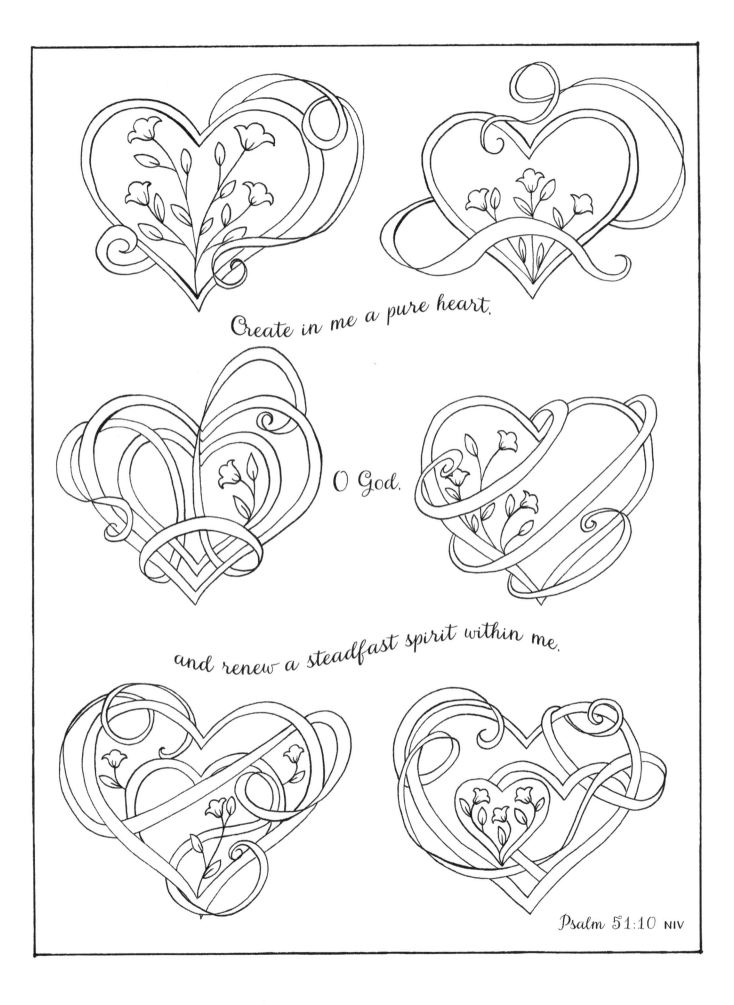

Create in me a pure heart,

O God,

and renew a steadfast spirit within me.

Psalm 51:10 NIV

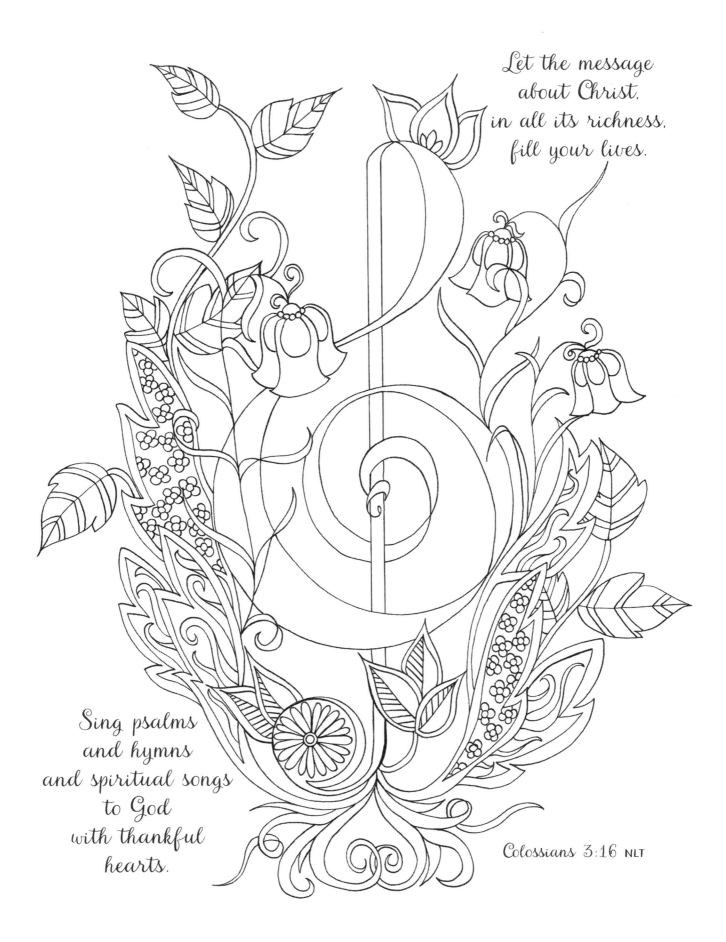

Let the message
about Christ,
in all its richness,
fill your lives.

Sing psalms
and hymns
and spiritual songs
to God
with thankful
hearts.

Colossians 3:16 NLT

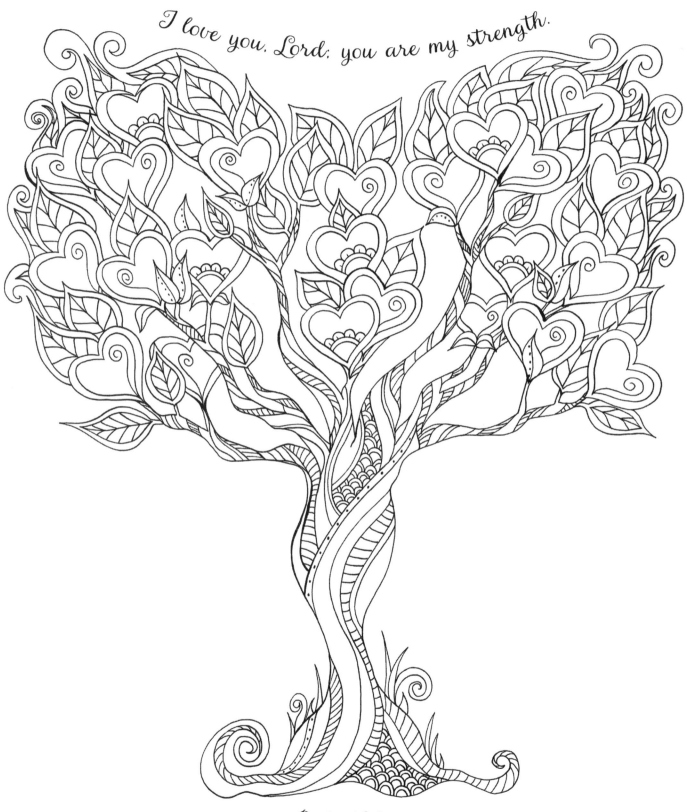

I love you, Lord; you are my strength.

Psalm 18:1 NLT

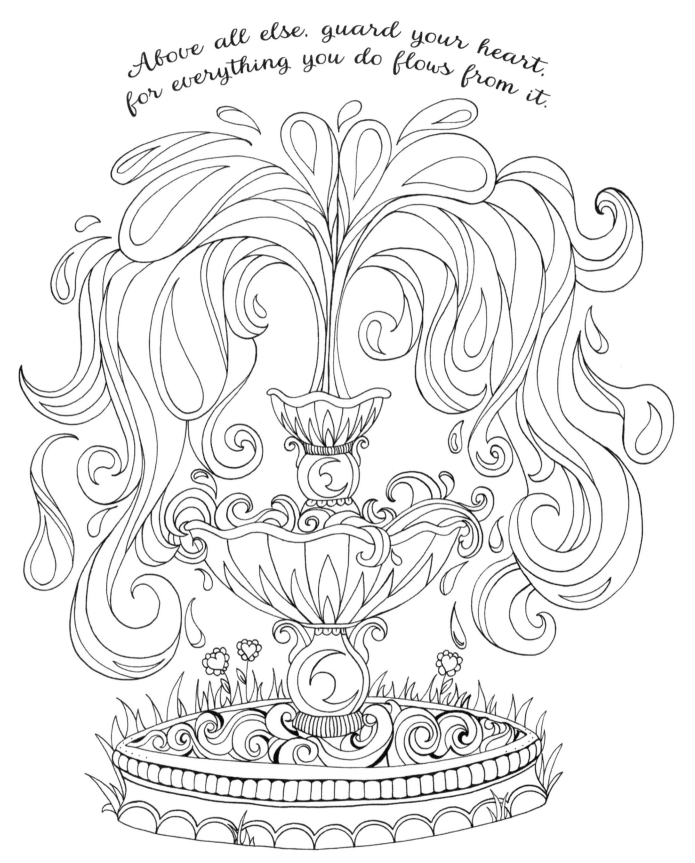

Above all else, guard your heart, for everything you do flows from it.

Proverbs 4:23 NIV

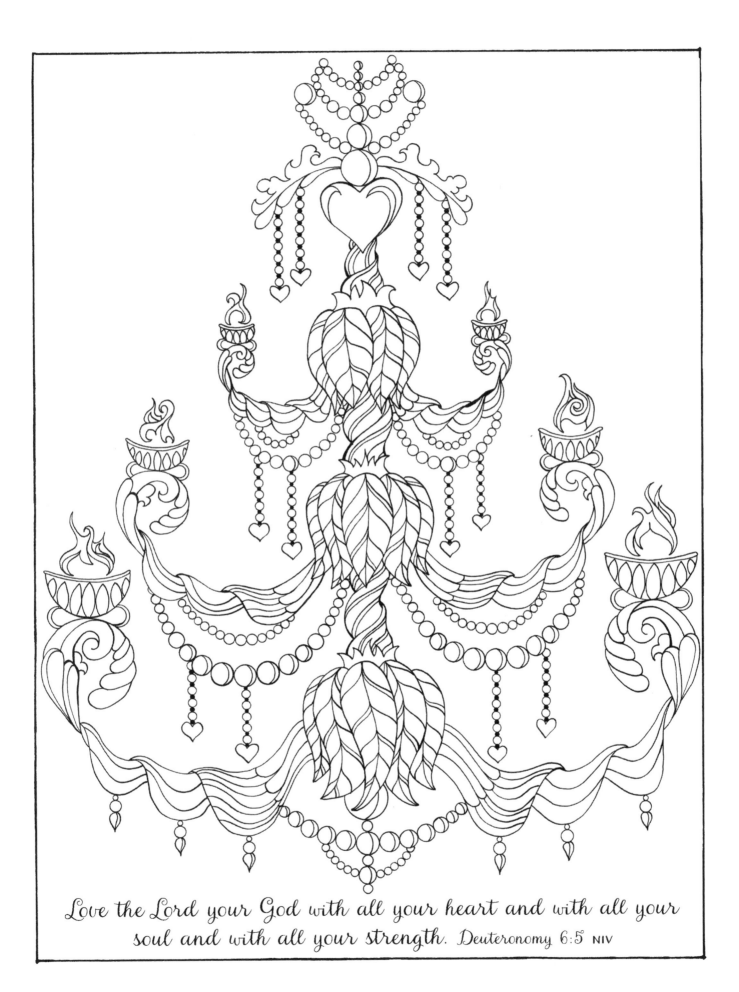

Love the Lord your God with all your heart and with all your soul and with all your strength. Deuteronomy 6:5 NIV

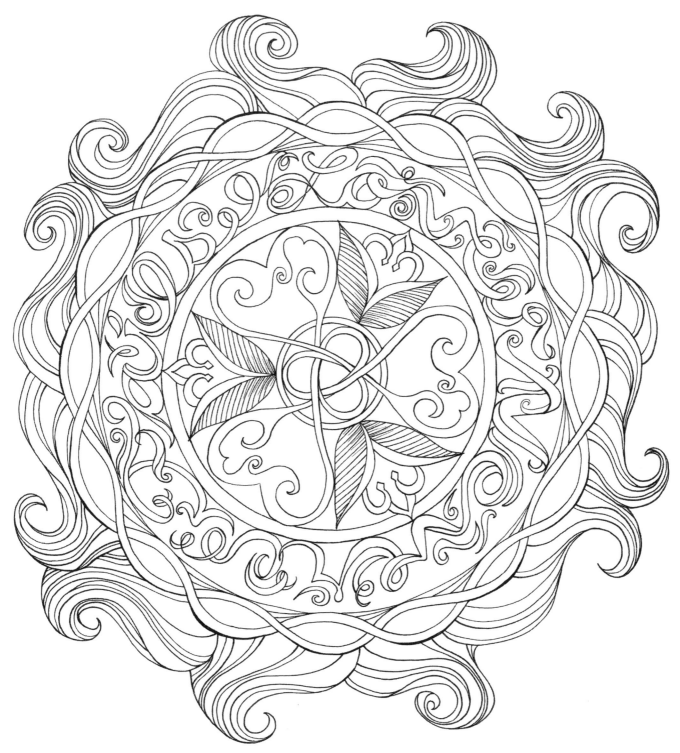

1 Corinthians 13:8 NIV

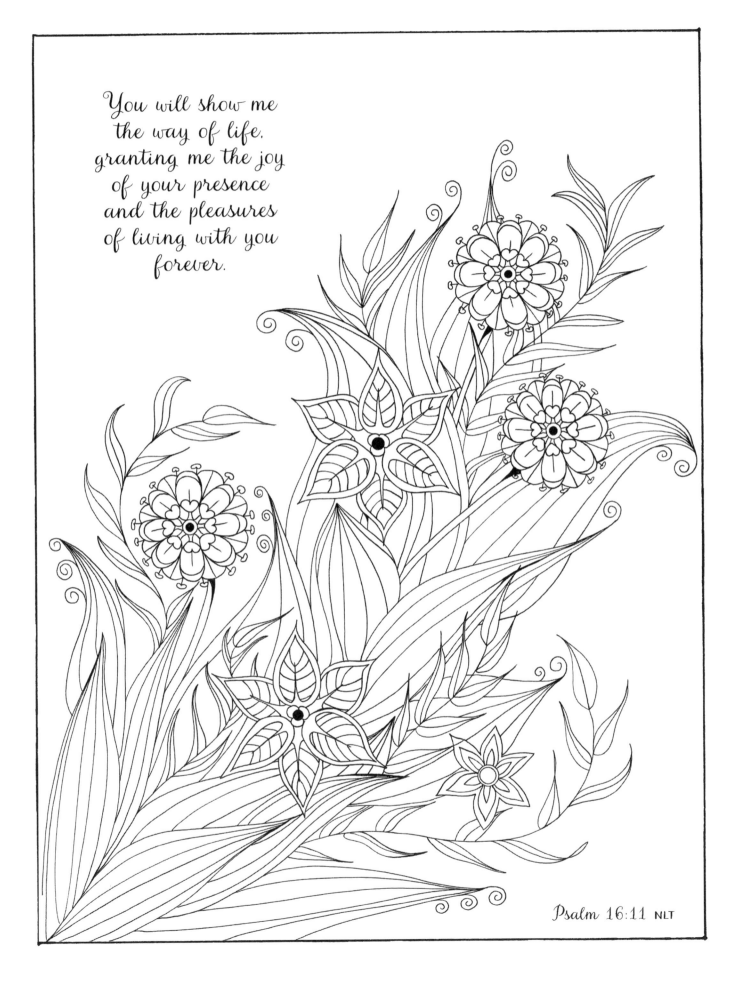

You will show me
the way of life,
granting me the joy
of your presence
and the pleasures
of living with you
forever.

Psalm 16:11 NLT

Above all, clothe yourselves with love,

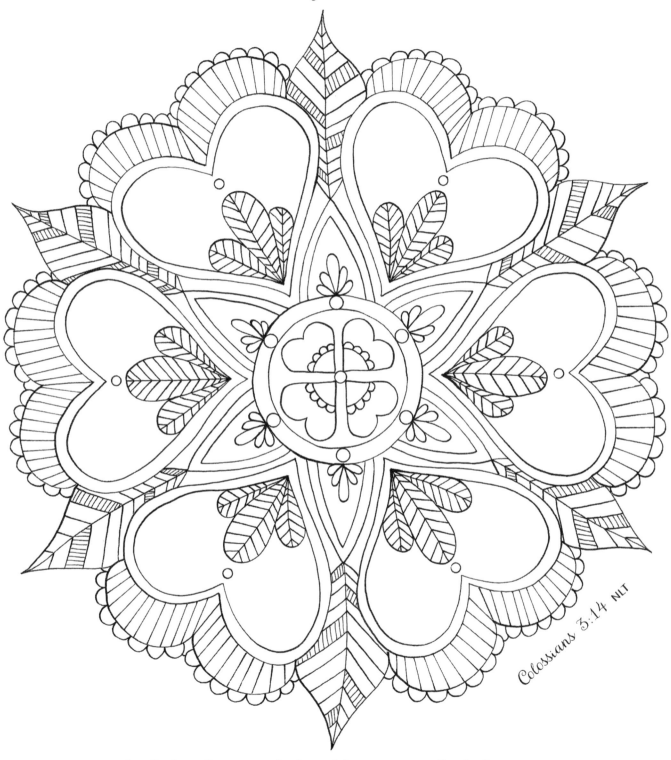

Colossians 3:14 NLT

which binds us all together in perfect harmony.

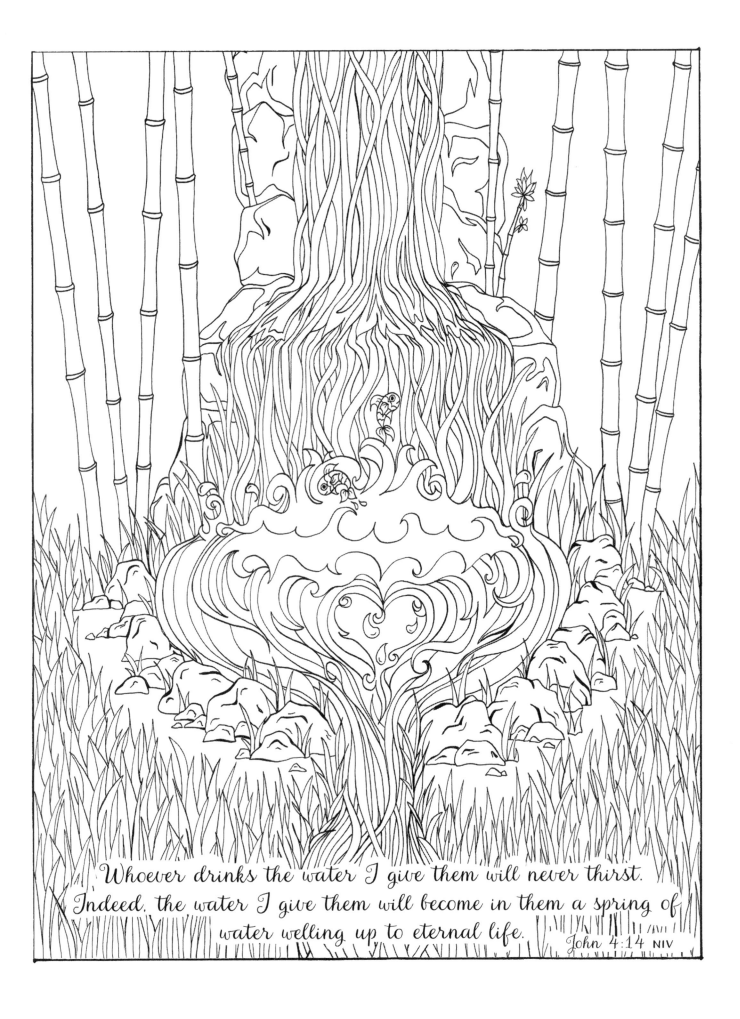

Whoever drinks the water I give them will never thirst.
Indeed, the water I give them will become in them a spring of
water welling up to eternal life. John 4:14 NIV

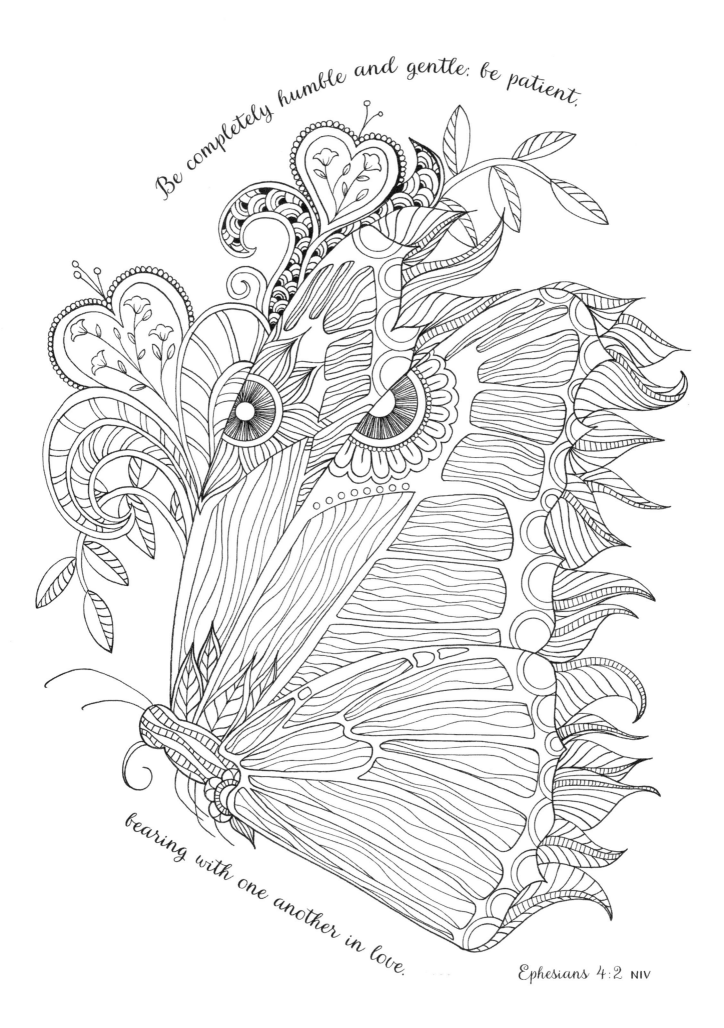

Be completely humble and gentle; be patient,

bearing with one another in love.

Ephesians 4:2 NIV

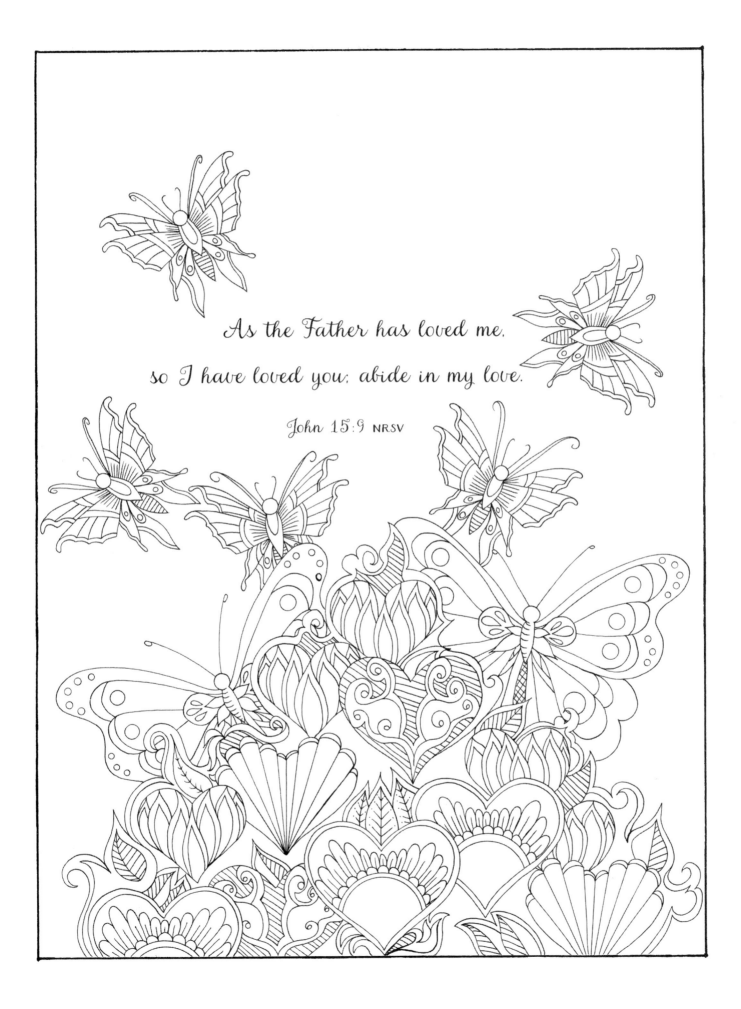

As the Father has loved me,

so I have loved you; abide in my love.

John 15:9 NRSV

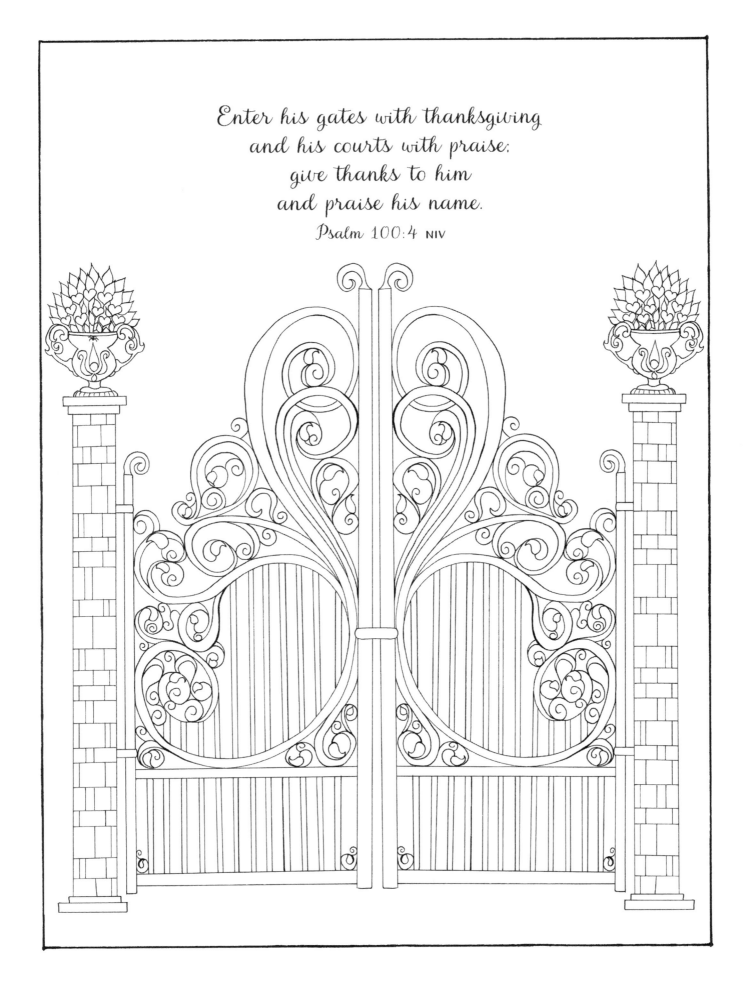

Enter his gates with thanksgiving
and his courts with praise;
give thanks to him
and praise his name.
Psalm 100:4 NIV

Beloved, let us love one another,
for love is from God, and
whoever loves has been born of
God and knows God.

1 John 4:7 ESV

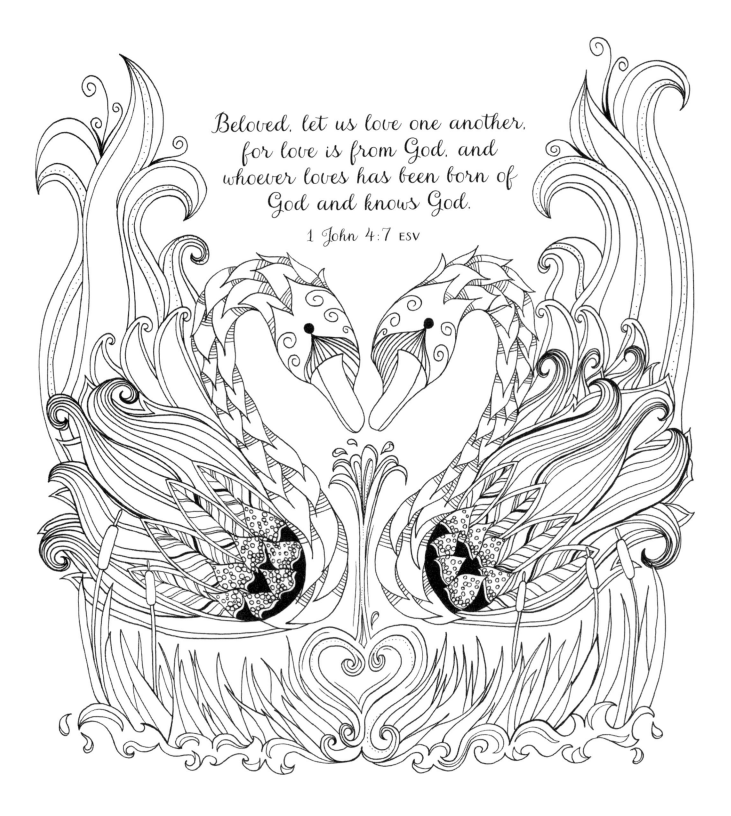

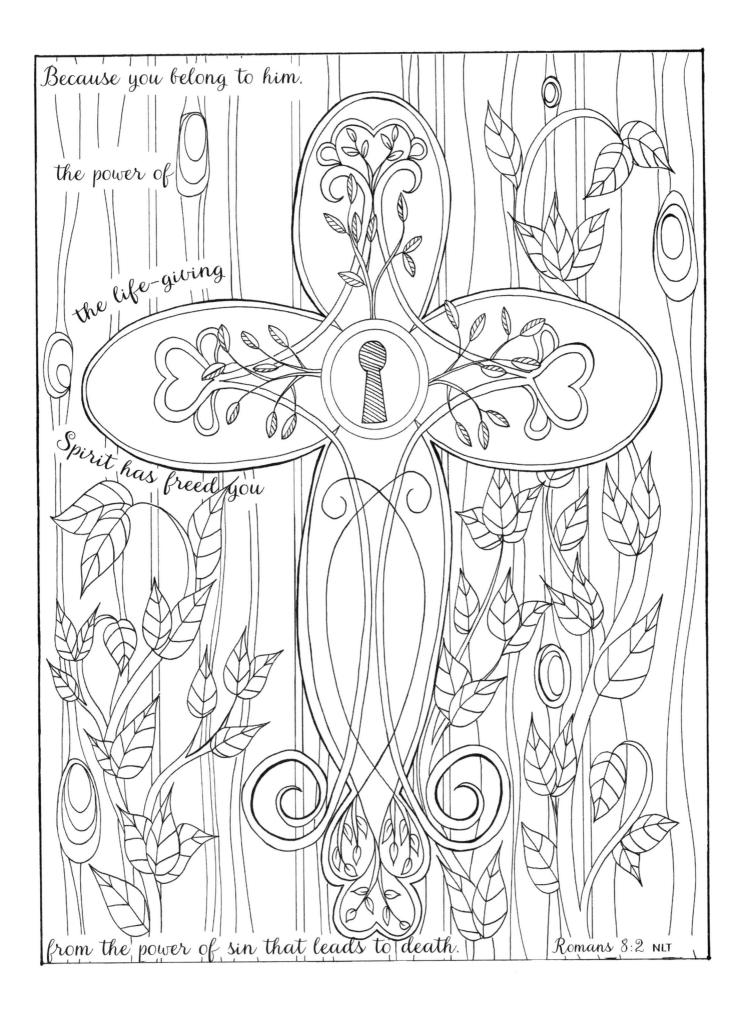

Because you belong to him,

the power of

the life-giving

Spirit has freed you

from the power of sin that leads to death. Romans 8:2 NLT

Shout joyfully to the Lord, all the earth;

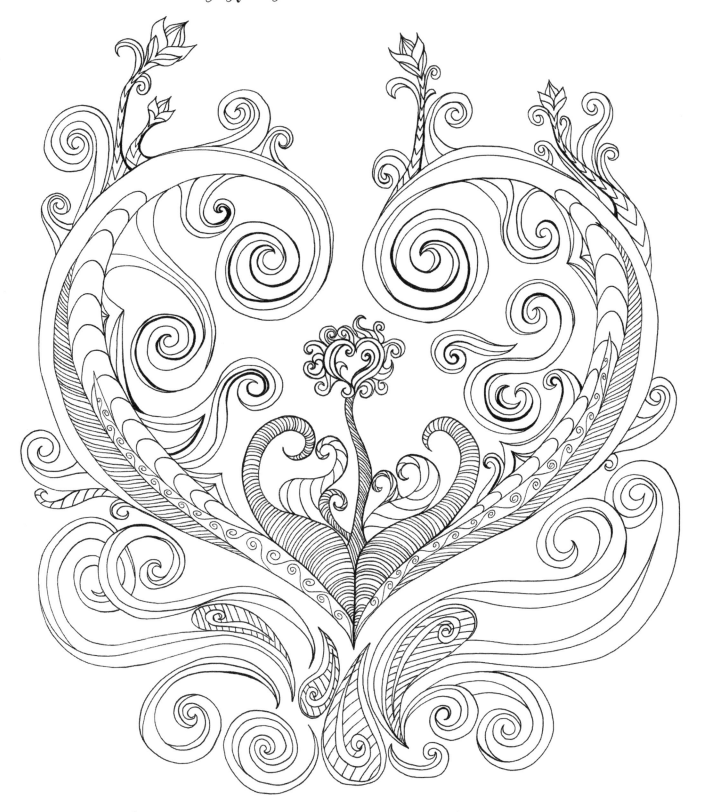

Break forth and sing for joy and sing praises.

Psalm 98:4 NASB

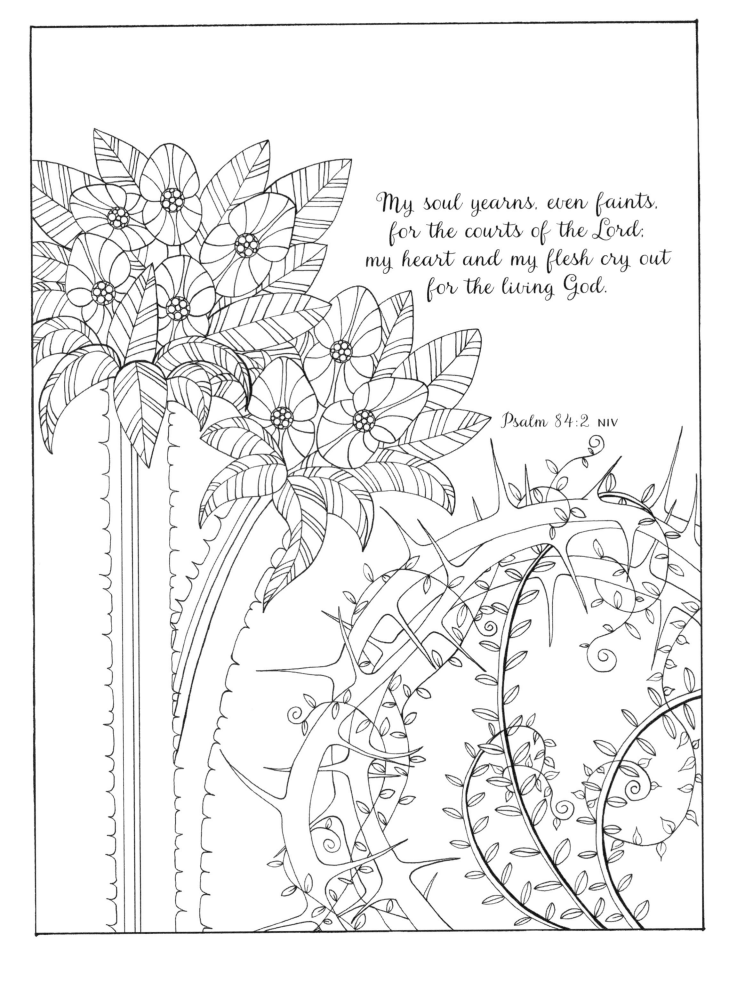

My soul yearns, even faints,
for the courts of the Lord;
my heart and my flesh cry out
for the living God.

Psalm 84:2 NIV

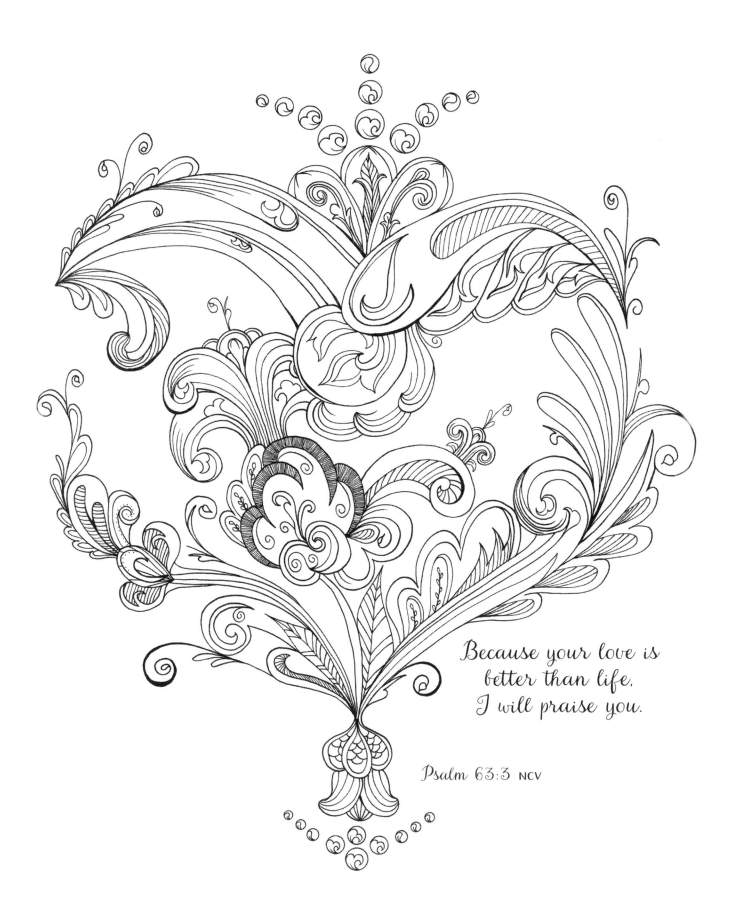

Because your love is
better than life.
I will praise you.

Psalm 63:3 NCV

The Lord is my strength and my shield;

my heart trusts in him, and he helps me.

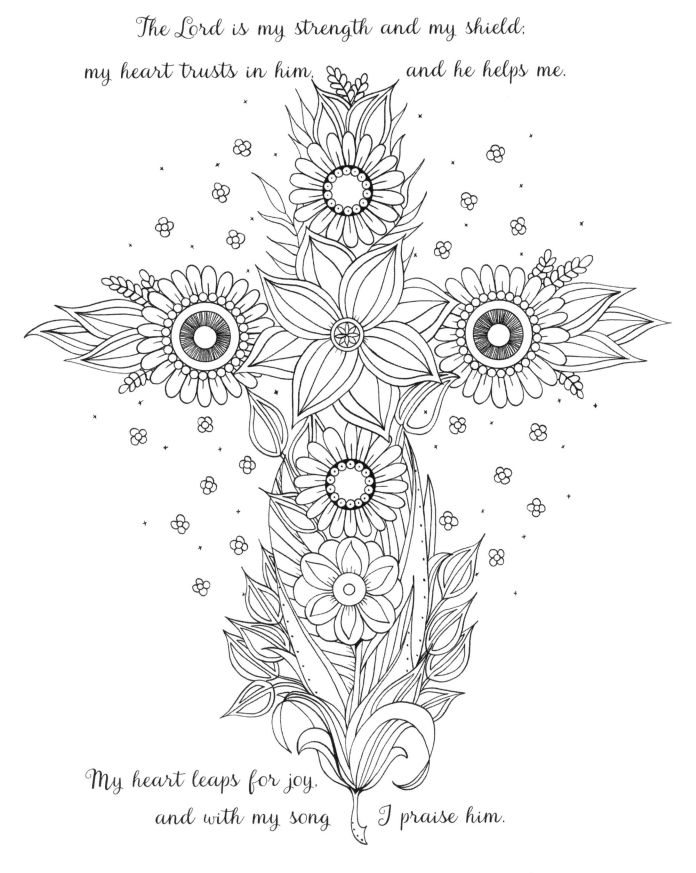

My heart leaps for joy,

and with my song I praise him.

Psalm 28:7 NIV

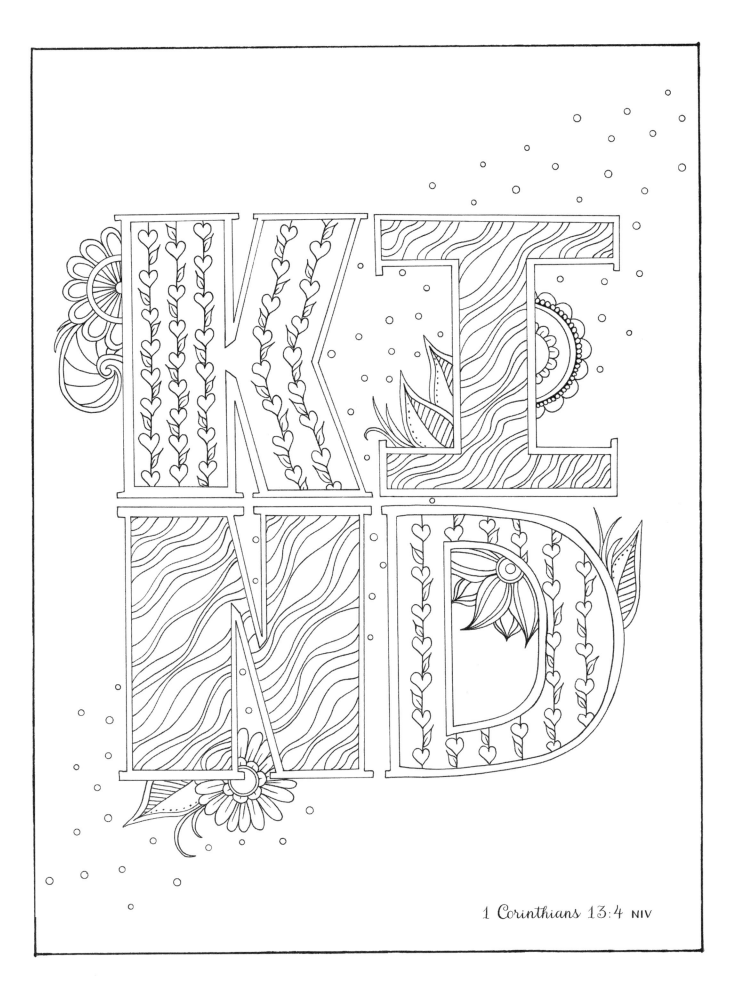

1 Corinthians 13:4 NIV

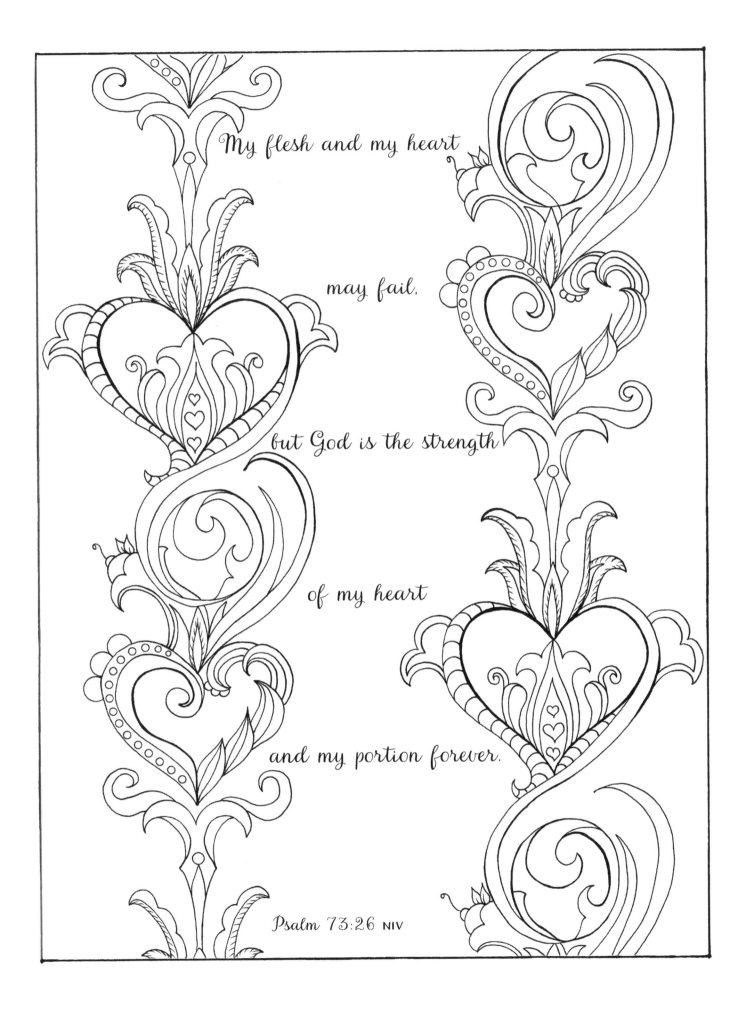

My flesh and my heart

may fail,

but God is the strength

of my heart

and my portion forever.

Psalm 73:26 NIV

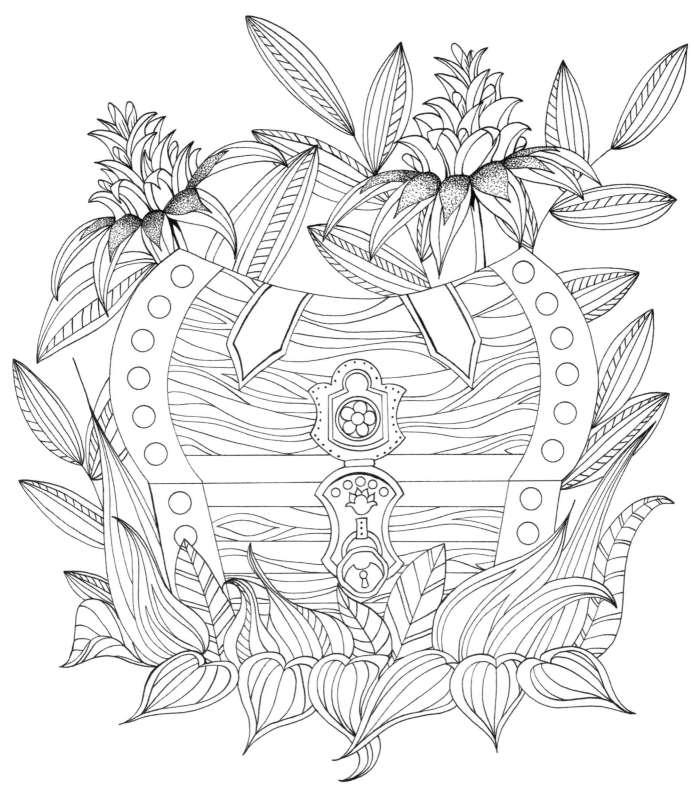

Wherever your treasure is,
there the desires of your heart will also be.

Matthew 6:21 NLT

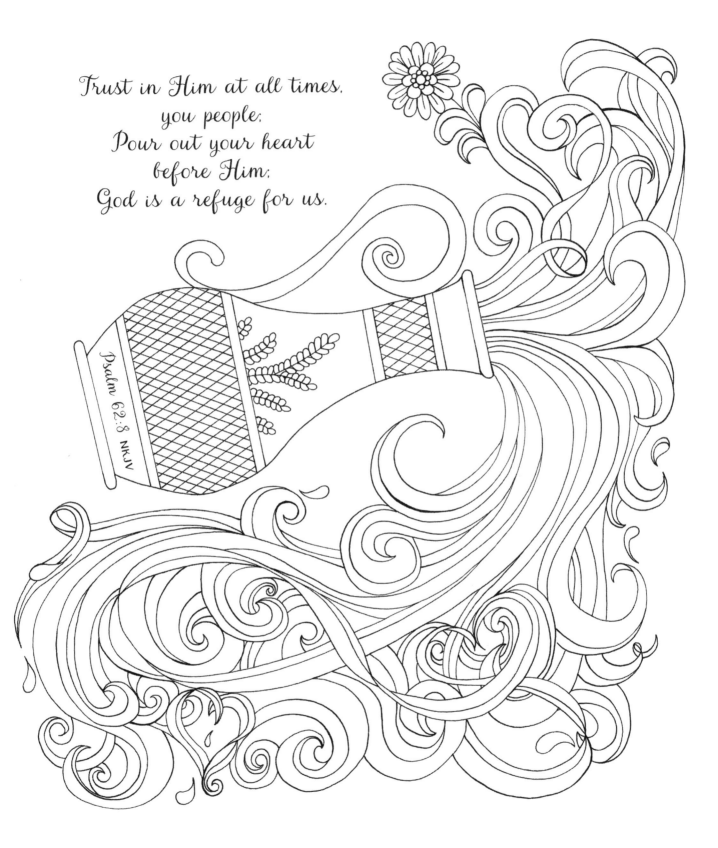

Trust in Him at all times,
you people;
Pour out your heart
before Him;
God is a refuge for us.

Psalm 62:8 NKJV

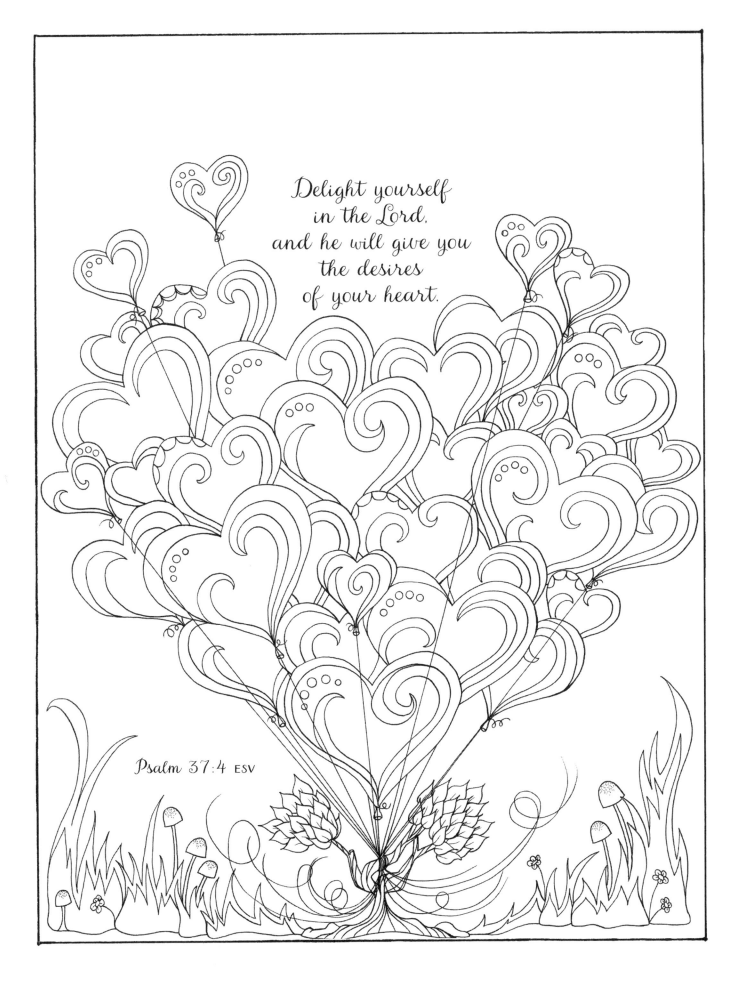

Delight yourself
in the Lord,
and he will give you
the desires
of your heart.

Psalm 37:4 ESV

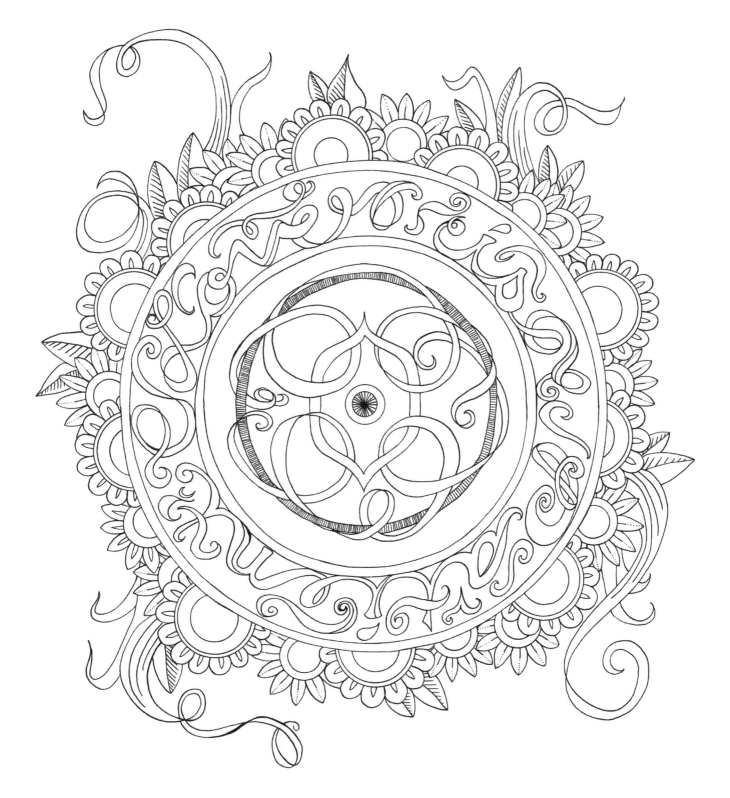

1 Corinthians 13:4

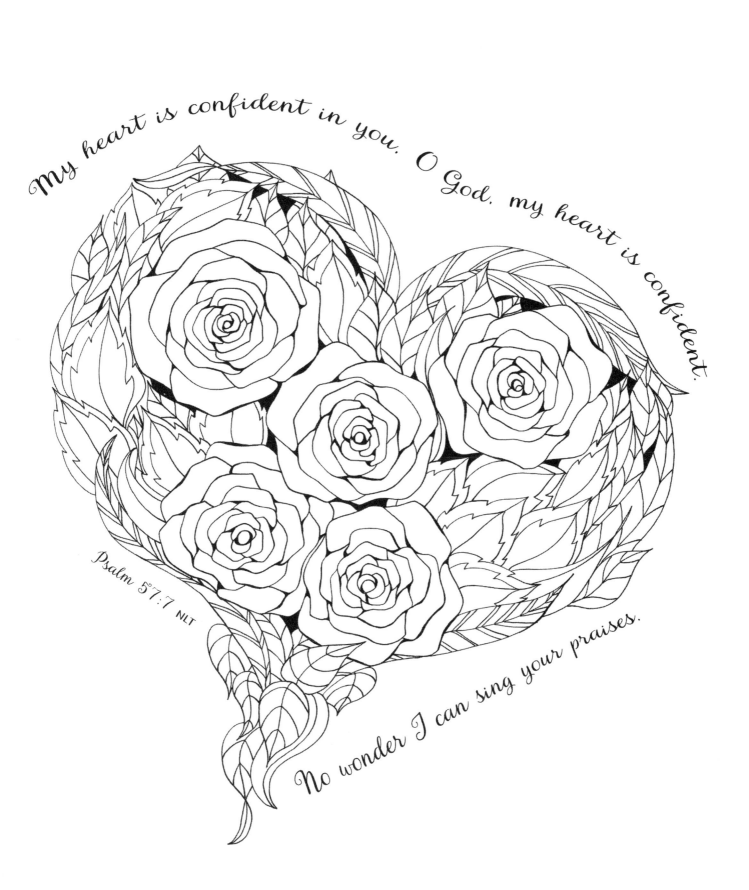

My heart is confident in you, O God, my heart is confident.

No wonder I can sing your praises.

Psalm 57:7 NLT

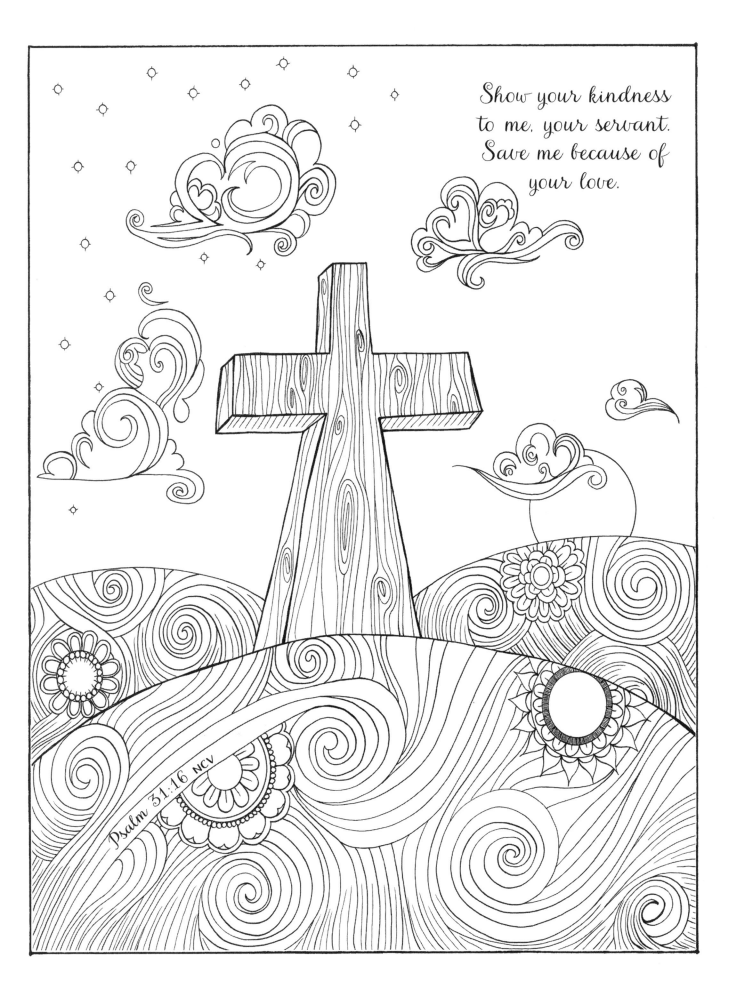

Show your kindness to me, your servant. Save me because of your love.

Psalm 31:16 NCV

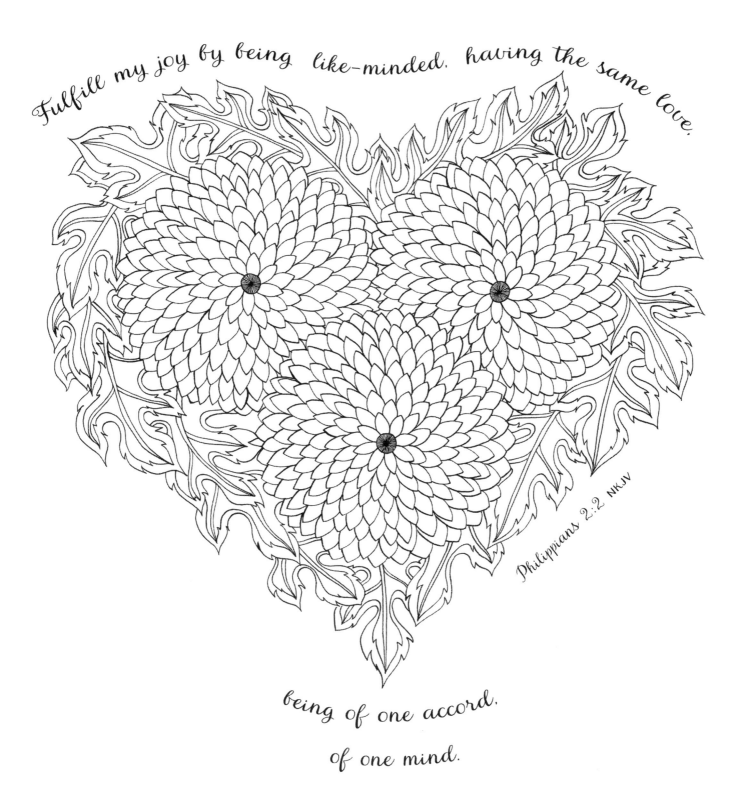

Fulfill my joy by being like-minded, having the same love,

Philippians 2:2 NKJV

being of one accord,

of one mind.

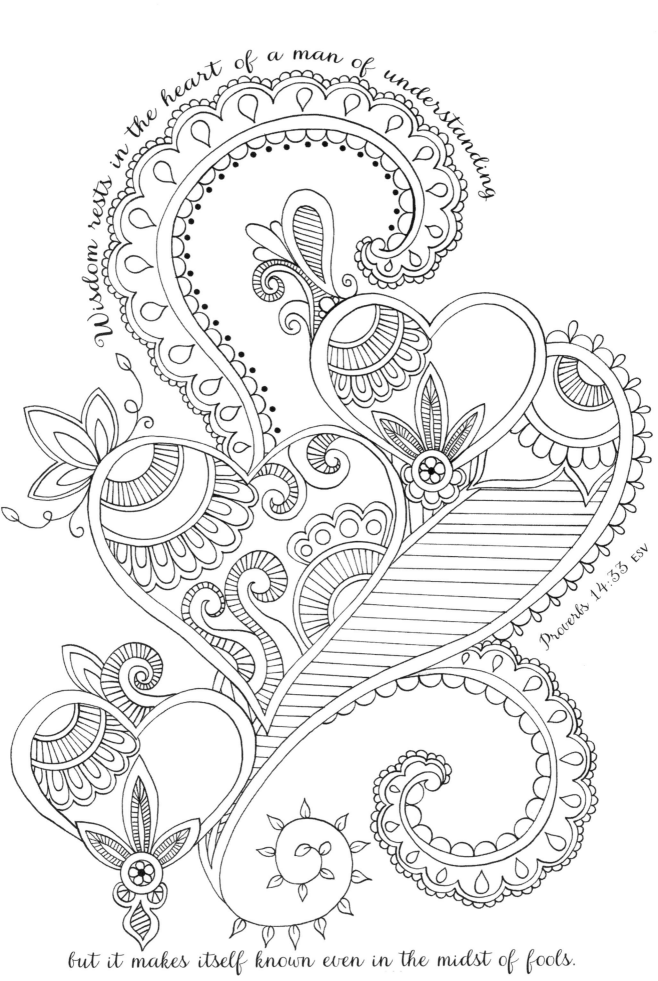

Wisdom rests in the heart of a man of understanding

Proverbs 14:33 ESV

but it makes itself known even in the midst of fools.

Set me as a seal upon your heart, as a seal upon your arm;
for love is strong as death, passion fierce as the grave.
Its flashes are flashes of fire, a raging flame.

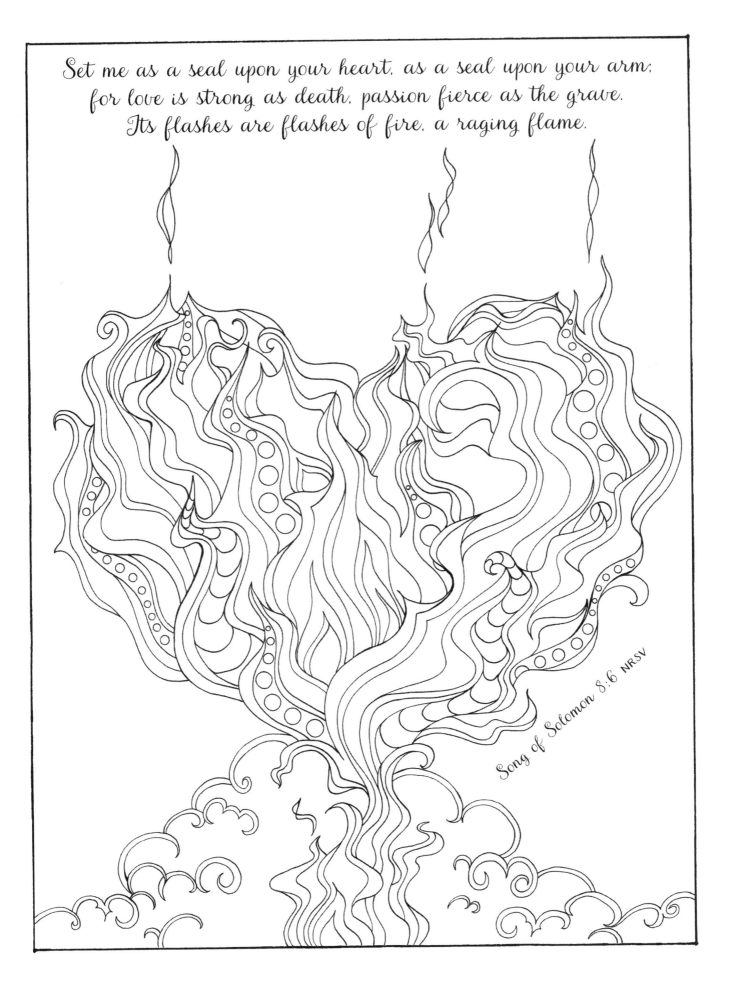

Song of Solomon 8:6 NRSV

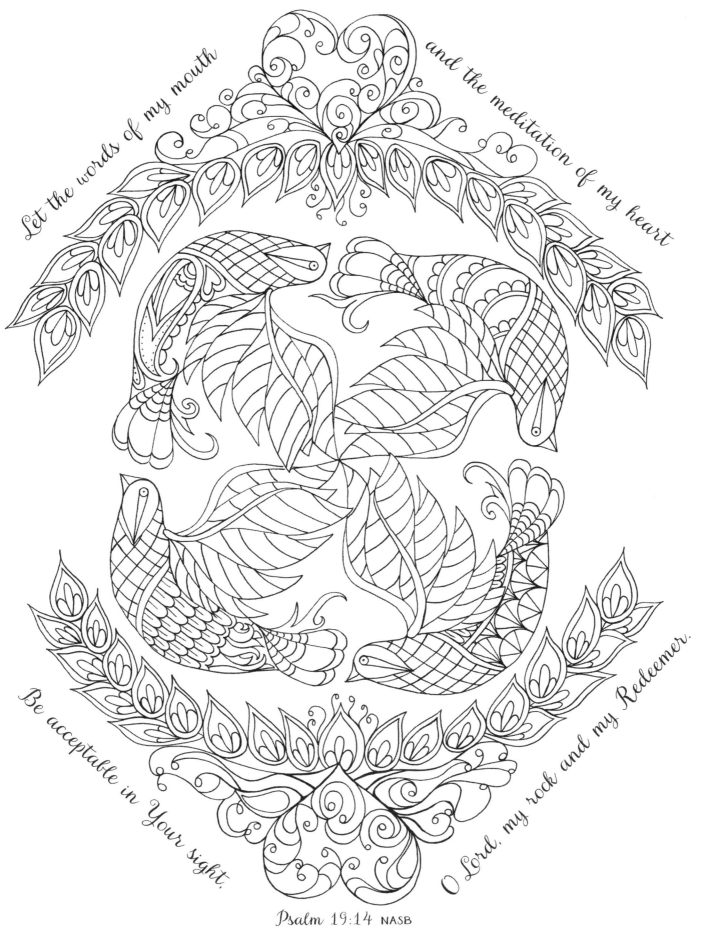

Let the words of my mouth and the meditation of my heart

Be acceptable in Your sight, O Lord, my rock and my Redeemer.

Psalm 19:14 NASB

Your roots
will grow
down into
God's love
and keep you
strong.

And may you
have the power to
understand, as all
God's people should,
how wide, how long,
how high, and
how deep his love is.

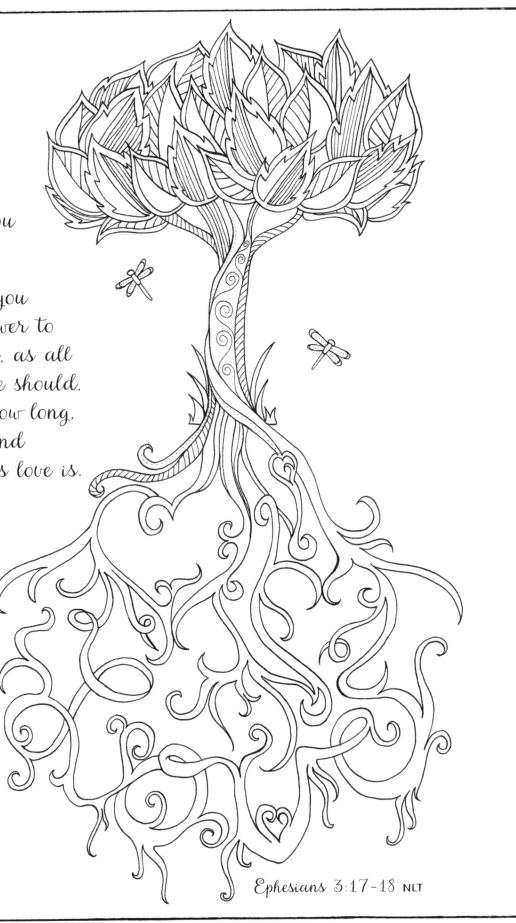

Ephesians 3:17-18 NLT

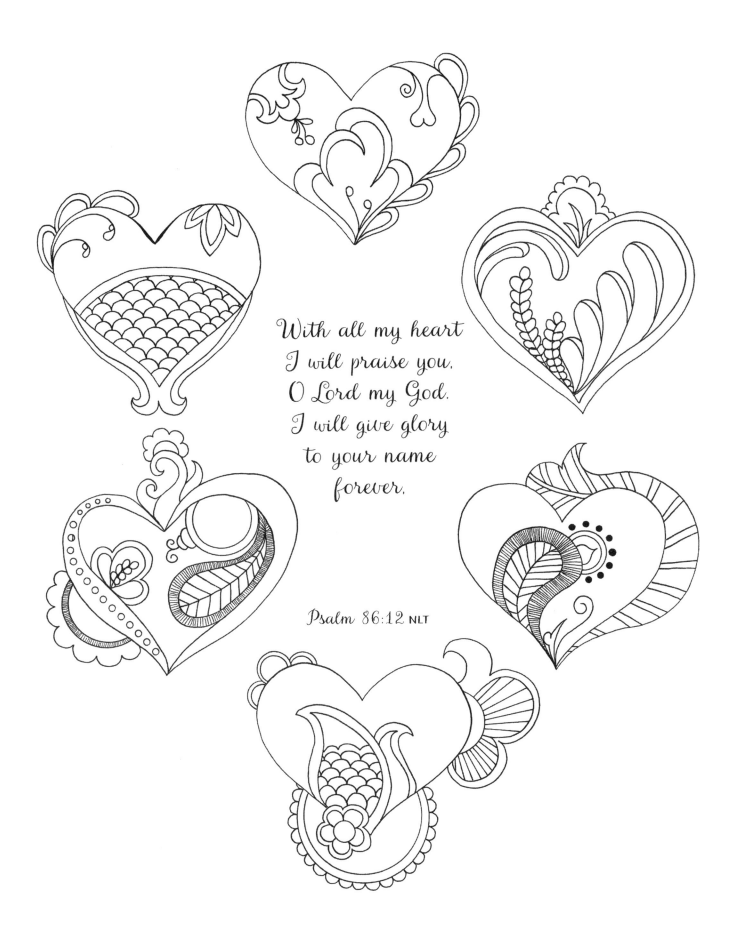

With all my heart
I will praise you,
O Lord my God.
I will give glory
to your name
forever.

Psalm 86:12 NLT

Serve each other with love.

Galatians 5:13 NCV

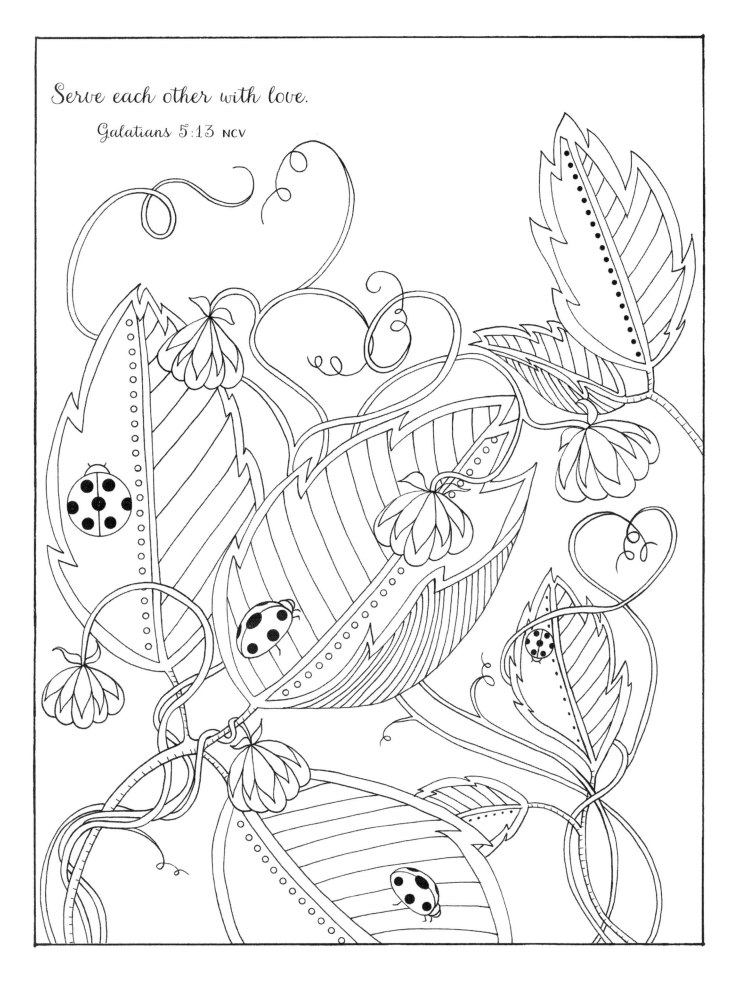

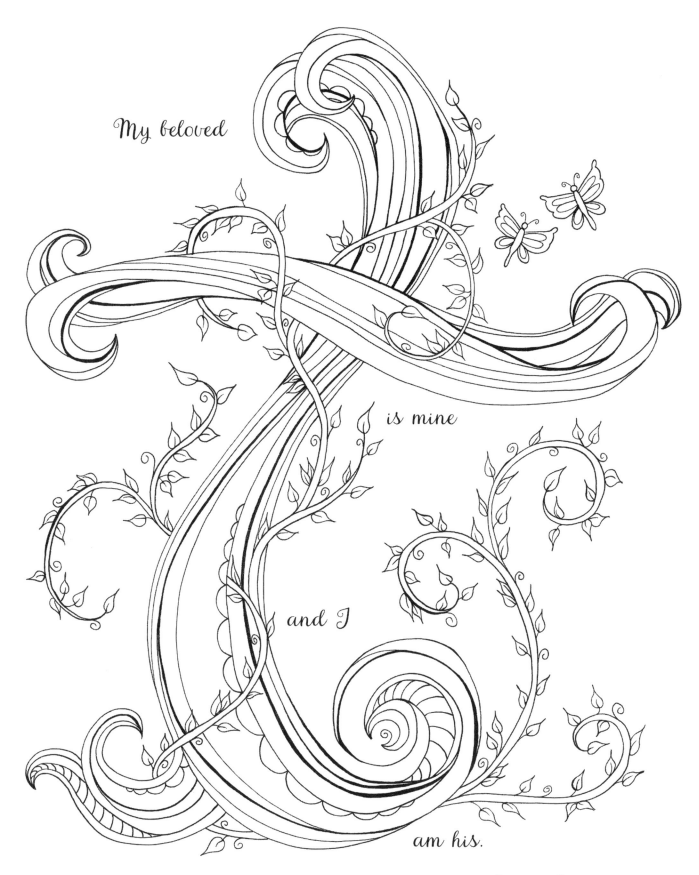

My beloved

is mine

and I

am his.

Song of Songs 2:16 ESV

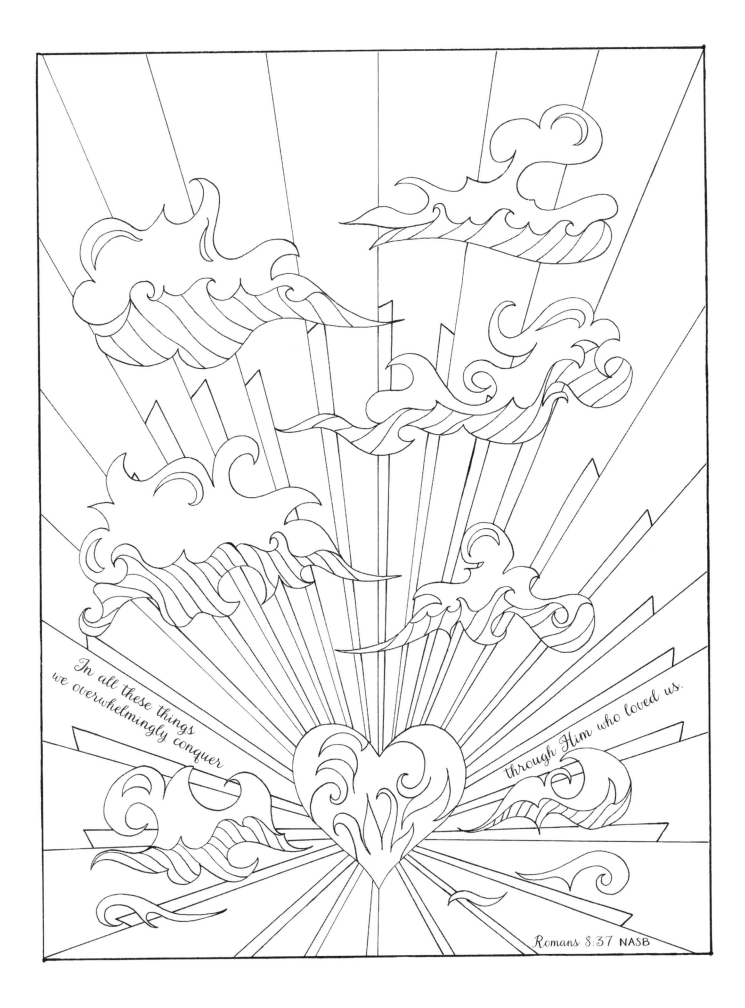

In all these things we overwhelmingly conquer

through Him who loved us.

Romans 8:37 NASB

I am the vine; you are the branches.

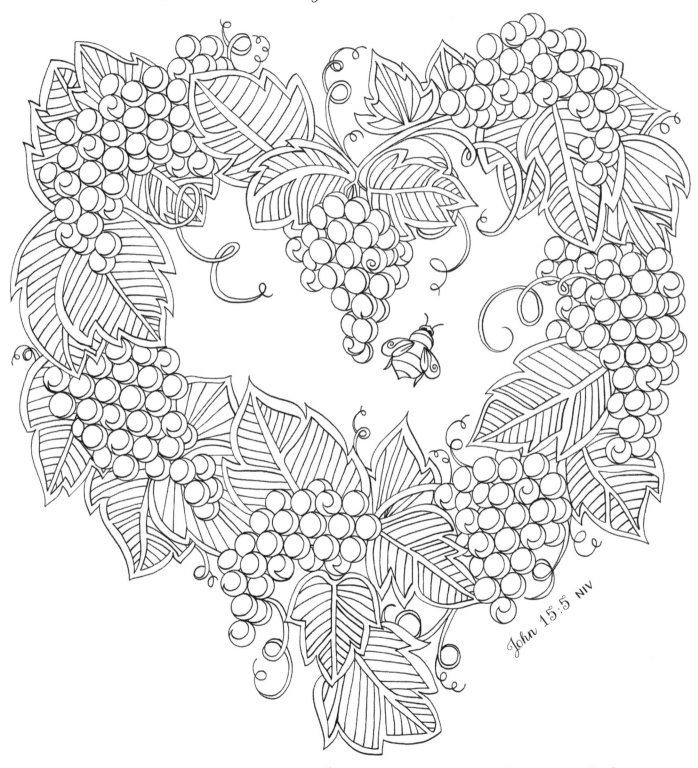

John 15:5 NIV

If you remain in me and I in you, you will bear much fruit;
apart from me you can do nothing.

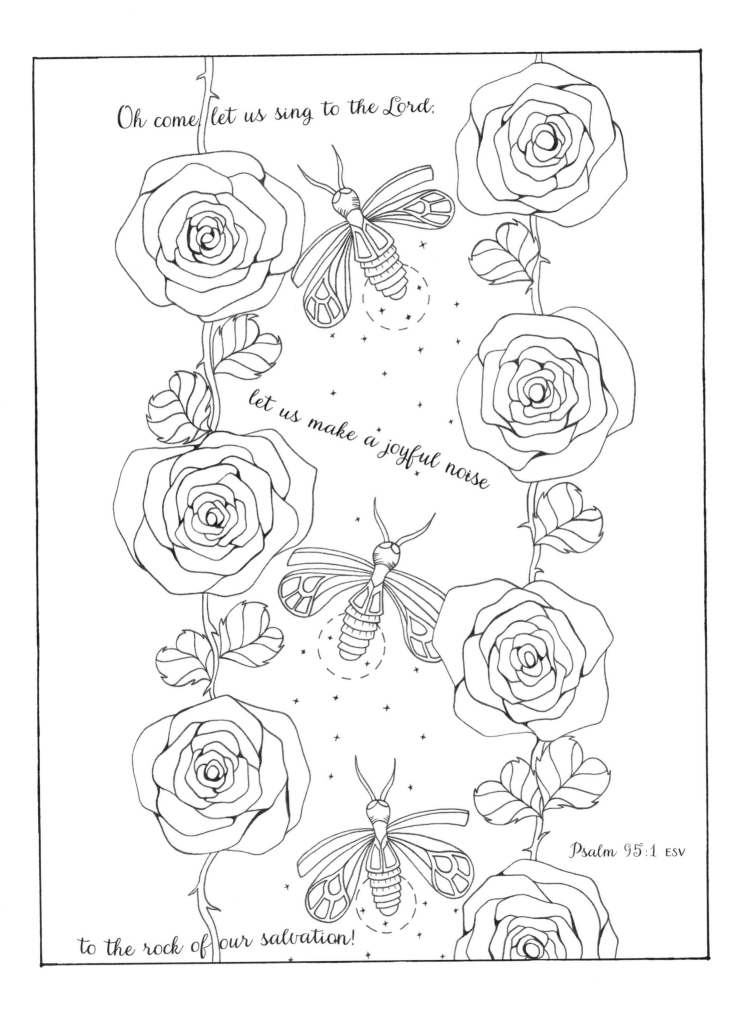

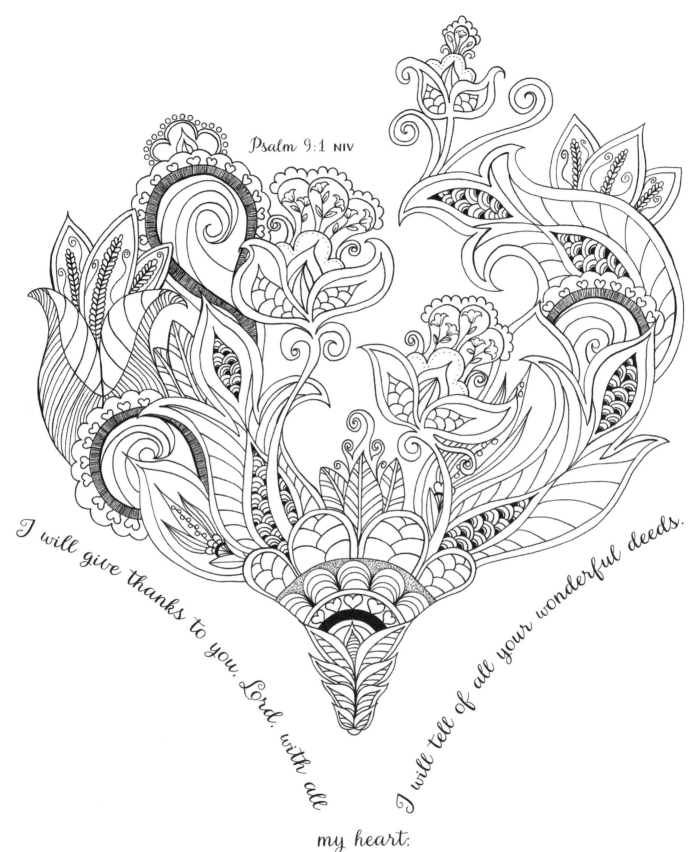

Psalm 9:1 NIV

I will give thanks to you, Lord, with all my heart;

I will tell of all your wonderful deeds.

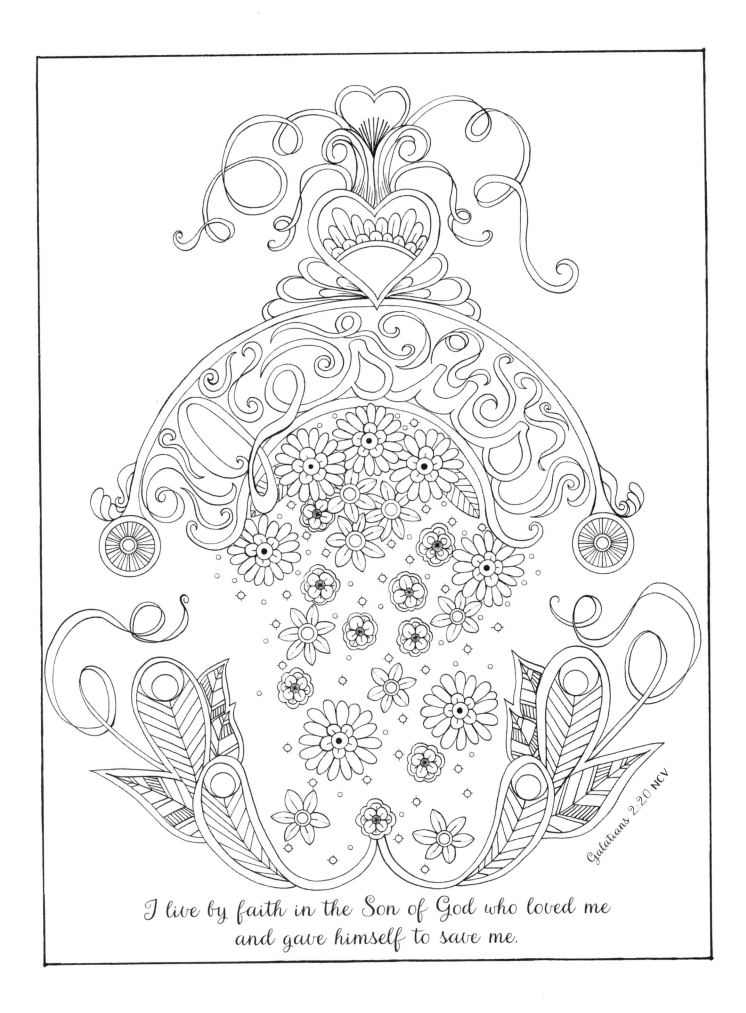

I live by faith in the Son of God who loved me
and gave himself to save me.

Galatians 2:20 NCV

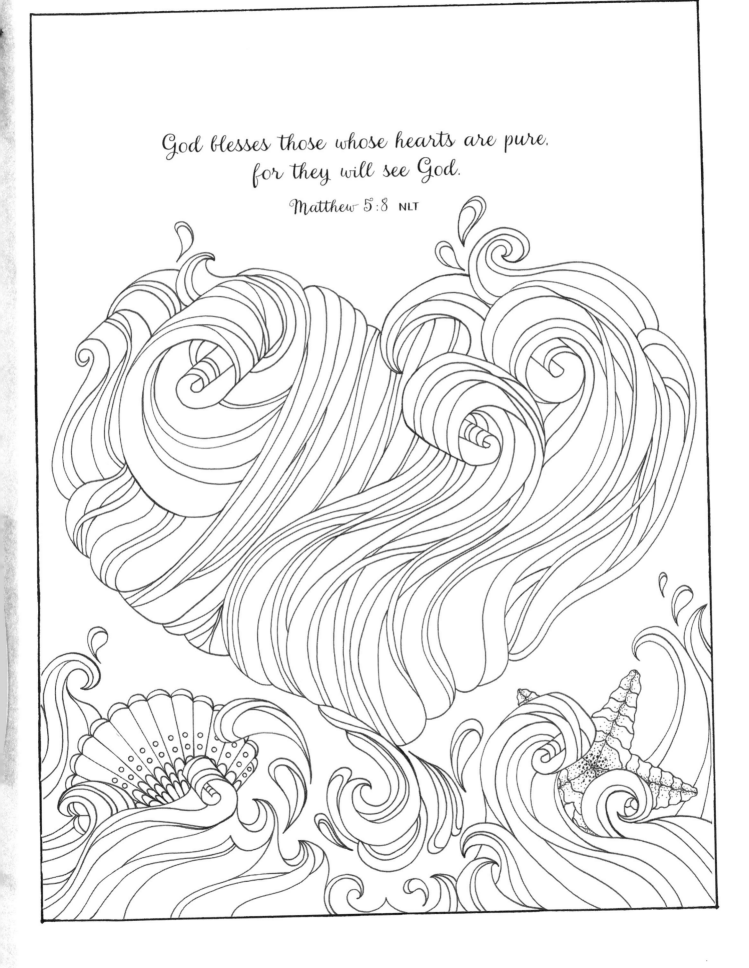

God blesses those whose hearts are pure,
for they will see God.

Matthew 5:8 NLT